IMAGES
of America

FORGOTTEN DETROIT

Today when people think of the word *Detroit* they picture a city. Occasionally they still use the word to refer to the automotive industry. During the industry's golden age, the two were truly synonymous. Both stood for grit and determination. The placard featured in this outdoor display of 1929 and 1939 Chevrolets proudly proclaims this spirit.

On the cover: The Woman's Exchange building on East Adams Street served a unique purpose in Detroit society. From 1888 to 1942, the exchange functioned as a consignment shop where members sold personal wares: baked good, used clothing, household items, and so on. Its primary clientele were previously affluent women who had subsequently fallen on hard times. Today this very recognizable building is the home of Cheli's Chili Bar, a popular restaurant owned by Detroit Red Wings defenseman Chris Chelios and a favorite among Detroit Tigers fans wandering over from Comerica Park. (Courtesy of the Walter P. Reuther Library, Wayne State University.)

IMAGES
of America

FORGOTTEN DETROIT

Paul Vachon

ARCADIA
PUBLISHING

Copyright © 2009 by Paul Vachon
ISBN 978-0-7385-6087-8

Published by Arcadia Publishing
Charleston SC, Chicago IL, Portsmouth NH, San Francisco CA

Printed in the United States of America

Library of Congress Control Number: 2008941787

For all general information contact Arcadia Publishing at:
Telephone 843-853-2070
Fax 843-853-0044
E-mail sales@arcadiapublishing.com
For customer service and orders:
Toll-Free 1-888-313-2665

Visit us on the Internet at www.arcadiapublishing.com

*To my wife Sheryl and to our son Evan,
for supporting my love of all things historical*

CONTENTS

Acknowledgments		6
Introduction		7
1.	Coming of Age: 1860–1899	9
2.	Building Anew: 1900–1919	23
3.	Dreams and Despair: 1920–1939	35
4.	Toil and Grit: 1940–1959	67
5.	Hope and Tragedy: 1960–1980	91
6.	Revival: 1981–2009	121
Bibliography		127

ACKNOWLEDGMENTS

Many people have lent me invaluable assistance in making this book a reality.

My sincere thanks go to Tom Featherstone and Mary Wallace, archivists at the Walter P. Reuther Library of Urban and Labor Affairs at Wayne State University for their generous help in procuring most of this book's images. My thanks also to Mark Bowden of the Burton Historical Collection at the Detroit Public Library and the staff at the Benson Ford Research Center for additional photographic assistance.

The help offered by Anna Wilson, my editor at Arcadia Publishing, was truly extraordinary. Any question or concern I had, no matter how esoteric, was always followed up on promptly. Her kindness and thoroughness are very much appreciated.

I also wish to thank Patrice Merritt, director of the Friends of the Detroit Public Library, and Dr. Charles Hyde of Wayne State University for reviewing the manuscript and offering helpful suggestions.

My sincere thanks also go to the many kind individuals who provided me with necessary information, especially Sgt. Eren Stephens of the Detroit Police Department and Aaron Jacobson of the Fredrick Douglass Branch, Detroit Public Library.

On a personal note, my thanks to my wife Sheryl for her proofreading expertise, my son Evan for his computer acumen, and my mother-in-law Mollie Stoffer for being a terrific historical consultant.

My thanks also to my parents, Maurice and Irene Vachon, for giving me the education necessary to write this book.

Lastly I would like to thank my friend Cynthia Sweier, whose encouragement and support gave me the gift of confidence needed to undertake this project.

Unless otherwise noted, all photographs appear courtesy of the Walter P. Reuther Library, Wayne State University.

INTRODUCTION

The "can do" image of Detroit is stuff of great legend: pioneer fort during its maiden century, the first to provide volunteers following the outbreak of civil war during the 19th, and culminating as the Arsenal of Democracy in the 20th. The latter sealed victory for the United States in World War II.

Without the capabilities of the automotive industry, victory could not have been won. This industrial might was also responsible for the phenomenal growth Detroit experienced during the first half of the 20th century. The city's population soared from 285,000 in 1900 to 1.8 million in 1950. Was this merely an accident of history? Could the automotive industry have developed elsewhere? According to *The Detroit Almanac*, the answer is no. While Detroit and several other cities possessed many of the key ingredients—capital, raw materials, access to rail and water transportation—Detroit was uniquely fortunate to have an imaginative group of innovators, a rarity in any place or any generation. The talents of Charles B. King, Henry Ford, John and Horace Dodge, and others all combined in popularizing the machine on which people are most dependent today.

As compelling as this is, a city as large and complex as Detroit hides dozens of fascinating topics just below the surface. For a brief time in the mid-19th century, Detroit was the home of a future U.S. president; the Detroit hockey team once went by two different names prior to becoming the Red Wings; over 20 years before the 1967 rebellion, another insurrection (arguably of a much uglier nature) upended the city.

Every day Detroiters drive through vintage neighborhoods unaware of the local luminaries who once lived there: automobile barons, retail magnates, future celebrities.

Pedestrians stroll past downtown monuments and historical markers without recognizing their significance—old automotive plants, storied places of worship, incomparable shopping venues, the homes of legions of working people. Detroit's size and multifaceted nature have created a captivating trove of history. Through text and pictures, this book seeks to uncover and bring to life many of these less-remembered anecdotes of local history.

The value of utilizing archival photography in relating these stories is tremendous. The beauty of the city's architectural treasures, the faces of Detroiters long departed, and much of the true character of the urban environment can best be appreciated by images enhanced by words.

Cities are fascinating places, in part because of their complex histories. Appreciating Detroit's past can be an important step in rallying efforts toward its revival.

Students and faculty pose at the entrance of Detroit High School in this photograph from the 1880s. Located on Griswold Street at Capitol Park, this building stood on the site once occupied by the old state capitol. The high school burned in 1893 and was replaced by the new Central High School, known today as Old Main on the campus of Wayne State University.

One

COMING OF AGE
1860–1899

The catastrophic fire of 1805 erased all physical reminders of Detroit's first 100 years. After the initial rebuilding, Detroit resumed in its second century the same role it played in its first, that of military outpost. Gabriel Richard, the visionary who penned the city's official motto after the fire, sought to usher in a new era.

A true renaissance man, Richard donated the printing press that published Michigan's first newspaper, the *Michigan Essay or Impartial Observer*. He also established the city's first school system in addition other numerous accomplishments.

The opening of the Erie Canal in 1825 and the Detroit–Chicago highway in 1829 (now known as Michigan Avenue) brought hundreds of newcomers to the city as the industrial age dawned in the ensuing decades. Shipyards, railroads, and foundries took their place alongside established crafts such as cigar making, carpentry, and shoe making.

The Detroit Board of Education was established in 1842, the Detroit Police Department in 1861. Temple Beth El, the Second Baptist Church, and other new congregations joined Ste. Anne de Detroit Catholic Church as major religious communities during this period. With each passing decade, Detroit appeared less a frontier fort and more as a city come of age.

Now located at the Michigan State Fairgrounds, this house was moved to its current location from 1369 East Fort Street. After its construction in 1849, Capt. Ulysses Simpson Grant (later general and president) lived here with his family during a Detroit assignment.

The building on the left is the city hall that served Detroit for much of the 19th century. Designed by Alpheus White in the Greek Revival style and built in 1835, it was used until a much larger structure was constructed on Woodward Avenue in 1871.

In this 1952 image, the Second Baptist Church on Monroe Street blends in with its surrounding structures, its historic character indiscernible. In 1836, 13 former slaves, unwelcome at the all-white First Baptist Church, established Second Baptist as the first black religious congregation in Detroit. In the years prior to the Civil War, the church served as the final link along the Underground Railroad, helping escaped slaves reach freedom in Canada.

The passport office building, as it was known later in its life, began as the U.S. post office and customhouse in Detroit. Built before the Civil War, its long tenure of service ended with its demolition in the early 1960s. The fourth floor was a 20th-century addition.

In the late 19th and early 20th centuries, the Romanesque style was often chosen by architects for government buildings. This image shows the old federal building on Fort Street. In the 1930s, it would be demolished and replaced on the same site with the structure Detroiters are familiar with today: the Theodore Levin Federal Courthouse.

The current dilapidated condition of the old Michigan Central Railroad train station tends to overshadow another mighty structure for the era of rail. The union depot located at Fort and Third Streets was built in 1891. In its heyday it served as the local hub for the Wabash Railroad plus the Flint and Pere Marquette Railroad and others. It was demolished in 1974 to make room for the downtown campus of Wayne County Community College.

The twin spires of the current Ste. Anne de Detroit Catholic Church rise majestically over southwest Detroit, the parish's current home. For decades the towers of Ste. Anne's have greeted motorists arriving from Canada via the Ambassador Bridge. Although very old, the current church is actually the community's eighth home. Founded in 1701, Ste. Anne's is the second-oldest continuously operating Catholic congregation in the United States. The careful observer will notice the outline of the Star of David in the large rose window over the main entrance, a rarity for a Christian church.

This 1890s image of Mariner's Church shows something peculiar by today's customs: leasing out space to a fruit market to defray expenses. From its inception, Mariner's has been an independent Anglican congregation and therefore has no parent diocese to assist with its support. In the 1953 image below (taken shortly before the building's move one block eastward), the commercial activity is gone. Note the difference in the appearance of the tower between the two images.

Worshipers fill Sweetest Heart of Mary Catholic Church to capacity for a 1953 funeral. The cavernous church on Russell Street has controversial origins. In 1885, Rev. Dominic Kolosinski, founder of nearby St. Albertus parish, was suspended from the priesthood for various reasons (one being an alleged relationship with a woman). After returning from a forced exile in the Dakota Territory, he rallied his followers and established his new congregation without ecclesial authorization. After appealing to Rome, however, Kolosinski and his parish were eventually reconciled with the Diocese of Detroit.

Detroit's oldest extant restaurant, the Roma Cafe, resides on Via Roma (Riopelle Street) near Eastern Market. The venerable inn has been serving outstanding Italian cuisine at the same location, in the very same building since 1890. Tradition gets no richer than this!

Many Detroiters may not know that the current Detroit Institute of Arts is not the museum's original home. This building, constructed in 1888, was first known as the Detroit Museum of Art. It served the city's residents until 1927 when the current Detroit Institute of Arts opened. The first structure, at Hastings Street and Jefferson Avenue, subsequently housed other public functions. It was demolished in the late 1950s to accommodate the Chrysler Freeway.

Prior to the construction of the recently restored Westin Book Cadillac Hotel, another inn occupied the same site. This image is of the Cadillac Hotel, built in 1888 by Daniel Scotten. The three Book brothers, James, Frank, and Herbert, grew up living in the hotel where their father was an employee. After receiving a sizable inheritance, the brothers sought to make Washington Boulevard the "Fifth Avenue of the Midwest," selecting the site of their childhood home as the location for their iconic hotel.

A charming link to the city's past is evidenced in the Detroit Club, located downtown on Cass Avenue. The current building, shown in this image, dates from 1892 and has been the site of many dramatic events. In the mid-1940s, young Henry Ford II used the club to plan the takeover of his family's company from Harry Bennett. Decades later, Lee Iacocca announced from the club his plan to restore the Statue of Liberty and Ellis Island.

Established in 1887, the Detroit Athletic Club was located on Woodward Avenue at Forest Avenue in what is known today as the city's midtown district. During its early years, the club was not for socializing or business networking but strictly for the pursuit of amateur sports. The club offered facilities for baseball, running, and bowling, among other activities. Outdoor events took place in a large open field behind the club. The location itself is most historic. After the building was demolished, the site was the home of Convention Hall where early stagings of the Detroit Auto Show were held. Later the Vernor's Ginger Ale plant occupied the corner. Recently an apartment tower for Wayne State University was completed on the site. During the late 19th century, amateur athletics served a duel purpose in the lives of young men of privilege: attainment of fitness and the enjoyment of camaraderie. These gentlemen formed the core of the club's original membership. The richly detailed image below shows the club's cricket team around 1890. (Above, courtesy of the Burton Historical Collection, Detroit Public Library.)

On March 6, 1896, Charles B. King became the first to drive an automobile on the streets of Detroit. Fascinated with all things mechanical, King learned of experiments by automotive pioneers Gottlieb Dalmer and the Duryea brothers and decided to construct his own. King's drive that day predated Henry Ford's automotive debut by three months. In a paradoxical twist, Ford followed King up Woodward Avenue that day—on bicycle.

Casting a watchful eye over Grand Circus Park is the stature of Mayor Hazen Pingree. Pingree, mayor from 1890 to 1897, was a true populist, ushering needed reforms and upsetting the city's elite. While still mayor, he was elected governor. Intending to hold both positions simultaneously, he was overruled by the courts, which forced him to choose between the two. He opted for the governor's job.

The statue of Gabriel Richard takes on a mysterious appearance after a light snowfall. This monument, located in a park named in his honor, celebrates his storied life. Born in France in 1767, Richard came to America shortly after ordination as a Catholic priest. He began the city's first school system, represented Michigan Territory in Congress, and established the Catholepistemaid of Michigania, forerunner to the University of Michigan. He died in 1832 during the cholera epidemic.

A life-size statue of Pres. Abraham Lincoln casts a pensive gaze over the lawn of the Skillman Branch of the Detroit Public Library. Commissioned in 1915 by Henry Leland, the founder of Lincoln Motors, the statue was located at the company's headquarters until 1986. After the facility was abandoned, Neal Shine, publisher of the *Detroit Free Press*, raised money for the statue's restoration and arranged for its new location.

Members of the Grand Army of the Republic hold an encampment near the Michigan Soldiers and Sailors Monument in 1895. The GAR, a fraternal organization of Union Civil War veterans, was formed shortly after the war to perpetuate its memory. In 1881, members created its successor organization, Sons of Veterans of the Civil War, to continue this tradition.

This rather odd monument was once on display in the center of Cadillac Square. It is known as the *Chair of Justice*, honoring Detroit's founder, Antoine de la Monthe Cadillac. Crafted of sandstone, it was unveiled as part of Detroit's bicentennial celebration in 1901. By 1941, the gradual decay brought on by age dictated that it be moved indoors. The statue was then donated to the Detroit Institute of Arts.

Euphoria and patriotism combined to a fever pitch on November 11, 1918, when World War I ended. Wild celebrations erupted to commemorate what has been called "the war to end all wars." The enthusiasm was so strong many people came to believe the Great War, as it was then known, would be the last ever fought.

Impromptu celebrations occurred citywide, but most were concentrated in the downtown area. Here a fire truck from the era joins the revelry. Visible in the background is a much smaller version of the venerable J. L. Hudson Company store before its numerous expansions.

Two
Building Anew
1900–1919

It is certainly no coincidence that the beginnings of the automotive age occurred simultaneously with the construction of some of Detroit's grandest structures. The original General Motors building, the Wayne County building, and the Pontchartrain Hotel on Woodward Avenue all made their debuts during this era. A new period of economic vitality had begun.

Detroit also benefited from the city beautiful movement of this era, an architectural trend emphasizing expansive public green spaces flanked by impressive public buildings, often in the Beaux-Arts style. Local examples are the Detroit Institute of Arts and the Detroit Public Library, and of course Belle Isle planned by noted landscape architect Fredrick Law Olmsted. With these impressive accomplishments it was clear that Detroit had found its place in the world.

This newfound fame won new political clout for the city of the straits. The careers of John Lodge, James Couzens, and James McMillen begot attention to Detroit just as the drumbeats of war grew louder.

The Second Home of the Ford – Piquette

After Henry Ford and John Grey organized Ford Motor Company in 1903 (Ford's third attempt to enter automobile manufacturing), the young company quickly outgrew its first factory on Mack Avenue. Construction soon began on a new facility at Piquette and Beaubien Streets in the Milwaukee Junction neighborhood (so named for the nearby intersection of several rail lines) east of Woodward Avenue. Built of brick and maple timbers, the new building housed the

1905–1910

...utgrown in six years —
...nd Beaubien, Detroit

production of Ford's earliest products, the Models A, B, C, F, K, N, R, and S. In early 1907, an experimental room was created on the third floor where Joseph Galamb, C. Harold Wills, and Henry Ford developed the prototype of the iconic Model T. Shortly after its initial appearance, production shifted to another Ford installation, the huge new Highland Park factory. (Courtesy of the Henry Ford.)

Remarkably, the Piquette plant survives today. This recent image shows the facility with its exterior cleaned. Currently being restored by a team of dedicated volunteers, the building is slated to become a first-class museum and educational center highlighting this pivotal element in Detroit's automotive evolution. (Author's collection.)

This home, at 140 Edison Street on the city's west side, was the home of Henry Ford from 1908 to 1915, immediately before his move to Dearborn. By this time, Ford's nearby Highland Park plant was the hub of his manufacturing empire. The home's current owners have lovingly maintained it, respecting its historical nature. (Author's collection.)

A bridge is constructed over East Grand Boulevard in this 1939 image, linking different sections of the Packard motorcar plant. Consisting of several structures, the factory, constructed between 1901 and 1911, was one of Albert Kahn's earliest industrial projects. The historic building No. 10 was the first industrial structure to utilize concrete reinforced with steel, providing enhanced strength. Packard is one of several automotive names now consigned to the past. Hudson, Nash, and Willys are others.

Many Detroiters may be surprised to learn that the city once supported a third daily newspaper, the *Detroit Times*. An alternative to the *Detroit News* and the *Free Press*, the *Times* was known for its raw, streetwise style and often featured incendiary headlines in its crime stories. Declining circulation prompted its owner, the Hearst Corporation, to sell the newspaper in 1960 to the Evening News Association, parent of the *News*, which immediately halted publication of the *Times*. Located downtown off Cass Avenue, the *Times* facility was used by the *News* for several years before being demolished.

Constructed in 1903, this magnificent building on Woodward Avenue was the first permanent home to Temple Beth El. Its architect, Albert Kahn, was also a member. Styled after the Pantheon in Rome with elegant Beaux-Arts detailing, it was later converted to a theater, and the widening of Woodward in the 1930s forced several changes to the building. Operating today as the Bonstelle Theatre, the structure is now without its setback from the street. The entrance and facade are also modified, almost beyond recognition.

Motorists traveling Woodward Avenue today are quite familiar with the majestic twin towers of the Cathedral of the Most Blessed Sacrament, located at Woodward and Boston Boulevard. This image shows the church before the towers' addition. After the Detroit diocese's elevation to the status of an archdiocese in 1937, Archbishop Edward Mooney asked permission from Rome to make Blessed Sacrament the new cathedral. Authorization was granted and renovations began. Due, however, to the high cost, construction of the spires could not be completed until after World War II.

Racial segregation, the norm in American life during much of the 20th century, included the military. This World War I–era image shows a company of African American soldiers drilling at Fort Wayne under the command of white officers.

The Red Arrows, also known as the 32nd Division of the U.S. Army, parade down Woodward Avenue in the spring of 1918. Consisting of National Guard units from Michigan and Wisconsin, the division served in Europe during the final months of World War I. After hostilities ended, the 32nd stayed on as a component of the army of occupation in Germany until April 1919. Reactivated during World War II, the division fought bravely in the southwest Pacific against the Japanese.

Mayor Oscar Marx makes a purchase of war savings stamps in front of city hall in 1918. During his administration (1913–1918), Marx became embroiled in the controversy over ownership of the city's streetcars. In the minds of many, the then privately held system charged excessively high fares. Marx's response was to regulate the system and call for limits on fares. The resistance from the transit system only escalated the quarrel. It was finally settled by his successor, James Couzens.

Politics and industry shared a strong bond in Detroit during the early 20th century. Like today, business leaders were often asked to serve on various public commissions. This image from 1930 shows (from left to right) James Couzens with his son Frank and Henry Ford with his son Edsel. James Couzens served as the elder Ford's controller in 1903 when Ford Motor Company was established. In 1913, Mayor Oscar Marx asked Ford to sit on the street railway board. He declined, deferring to Couzens. This launched Couzens's political career, eventually propelling him to police commissioner, mayor, and U.S. senator.

Detroit's illustrious (and often underappreciated) buildings were crafted by a number of outstanding architects whose legacies are enjoyed today. Albert Kahn is unquestionably a preeminent member of this group. The Fisher Building, the original General Motors building (now Cadillac Place), and the Ford Rouge complex are just a few of his many noteworthy accomplishments. Kahn also designed his personal residence on Mack Avenue, now home to the offices of the Detroit Urban League. Kahn's original career aspiration was to become an artist, but he turned to architecture as a result of his being color-blind.

Although the entrance of women into the workplace during World War II is well documented, World War I also saw this trend, albeit in smaller numbers. In this image, a group of female workers are studying the design of an engine block. Note the oversize jumpsuits and the ill-suited shoes. In the picture below, an employee of the Maxwell Motor Company uses an instrument called a gage to check munitions for the proper diameter.

33

By the 1920s, the city's core was well developed along a truncated version of Justice Augustus Brevoort Woodward's original plan. Woodward's vision called for a series of traffic circles arranged to serve as primary intersections, similar to Washington, D.C. The plan came to only partial fruition, however, due to uncooperative landowners. This dramatic aerial image of Grand Circus Park looking south shows both the beauty and the unrealized potential of Woodward's design.

Three

DREAMS AND DESPAIR
1920–1939

The renaissance of affluence, culture, and sophistication that coincided with the emergence of the automotive industry continued during the Roaring Twenties. Signature office buildings, ornate theatrical venues, and exemplary new schools provided evidence of this growth, in addition to hundreds of new homes and apartments for the upper middle class. Detroit became known as "the Paris of the Midwest."

By the late 1920s, however, problems began to emerge. African Americans, with few exceptions, did not share in the abundant prosperity. The frustration inflicted by ongoing Prohibition produced a prolific and often violent illegal liquor trade. At one point some 25,000 speakeasies allowed patrons to imbibe.

The hardships created by the 1929 stock market crash and the subsequent Depression were severe. Bank failures, breadlines, and the sight of crowds of unemployed men became commonplace. On November 1, 1929, a soup kitchen opened at St. Bonoventure Monastery on Mount Elliott Street by Solonus Casey and Herman Buss. What they intended as a temporary measure remains open today.

One of the grand dames in local banking history was the National Bank of Detroit. Created from the remnants of several failed Depression-era banks, National Bank of Detroit was recapitalized by the General Motors Corporation. Manufacturer's National Bank was created by Ford Motor Company in the same manner. This image shows opening day at the new National Bank of Detroit, March 24, 1933. The bank continued as a local corporate fixture until the 1990s when it was absorbed in a series of mergers with out-of-town banks.

Elial Saarinen's innovative designs brought a freshness and beauty to Detroit's architectural scene rivaled by few. While his most famous work is the magnificent Cranbrook campus in Bloomfield Hills, one of Saarinen's best visions was never realized: his 1920s plan for the Detroit Civic Center (below). As was the case with so many other planned projects, the Depression and World War II prevented its construction. When eventually built, the complex was of a distinctly modern style.

Saarinen's original 1924 concept for the civic center differs markedly from the version eventually constructed. According to W. Hawkins Ferry, in *The Building of Detroit: A History*, the plan called for a domed structure that would serve as a war memorial and a conference center. Behind it would rise a tall government office building resembling the Chicago Tribune Tower. At the water's edge a graceful colonnade would line the river. A new plan was drafted after the war, similar to the one eventually built.

Often overshadowed by the J. L. Hudson Company, its more prominent sibling, Crowley Milner and Company occupies a special niche in Detroit retail history. Pictured here are Daniel Crowley (seated) with, from left to right, subordinates James Crowe, Elmer Schlick, and James Janis. Founded as the successor to Pardridge Blackwell, a bankrupt department store, Crowley's emerged during the 1920s as an upscale retailer featuring European fashions and an excellent grocery store. By the later part of the decade, Crowley's was the largest department store in Michigan. Through effective management, Crowley's survived the lean Depression and war years. Postwar suburbanization forced the company to open satellite stores outside the city. These relatively small stores, however, were generally in poor locations, ultimately leading to the company's bankruptcy in 1999.

Hudson's was not the only local store that entertained the public with parades. This marching band proceeding down West Adams Street near Grand Circus Park delights pedestrians during the 1932 holiday season. Crowley's also featured music and choral singing in its stores at holiday time.

The Detroit Lions play at the University of Detroit stadium in 1934, the year the team moved to Detroit from Portsmouth, Ohio, where it was originally chartered. The name Lions was chosen in keeping with the wildcat image already established by the baseball Tigers. The University of Detroit would be the team's home until 1938 when it moved to Briggs (later Tiger) Stadium.

In recent years, the streets radiating south from Grand Circus Park have been dubbed the "necklace district." This image, taken from a more distant vantage point than the one on page 38, shows just how integral this component is to the rest of downtown. The absence of expressways in this image demonstrates downtown's seamless relationship to its surrounding neighborhoods.

New models of the day are displayed at the 1931 Detroit Auto Show, then held at Convention Hall at Woodward and Forest Avenues. The show began in 1907 at Beller's Beer Garden, located at Riverside Park on Jefferson Avenue. That first show was staged in tandem with an exhibition of hunting and fishing equipment. Several other venues have also hosted the show, including the Michigan State Fairgrounds Coliseum and Cobo Conference and Exhibition Center, its current home. Known today as the North American International Auto Show, it ranks as one of the premier automotive exhibits in the world.

Cascading rivers of seized spirits were a common sight during the time of Prohibition. Due to the proximity of Canada (where liquor continued to be legal), Detroit's exposure to bootleggers and rumrunners exceeded that of most U.S. cities. The never-ending cat-and-mouse game between the authorities and smugglers gradually became refined to a science. This 1929 image from the *Detroit News* is labeled to show the elaborate lengths utilized to evade "the revenuers." The Purple Gang, a predominantly Jewish organized crime group, "owned" this operation. The Purples even had a subgroup of boat owners dubbed the "Little Jewish Navy" who would procure the alcohol from Canada and transport it across the river.

The federal Prohibition Commission was charged with enforcing the Volstead Act, the law mandated by the 18th Amendment, which banned most consumption of alcohol. Pictured here are Detroit agents Bernard Wait (far left) and Seymour Loman (far right) flanking James Doran, federal commissioner of Prohibition. Until 1930, the commission served as a component of the Department of the Treasury. After 1930, it shifted to the Department of Justice.

Several female members of the Detroit Police Department display their service revolvers in this c. 1930 image. Women began serving in the department in 1920 with the creation of the Women's Division. Assignments mostly involved crimes affecting women and children. Female officers did not begin routine patrol duty until 1974.

Public displays of overt racism were commonplace during the 1930s. This 1938 image shows an angry mob in front of the fire station on Livernois Avenue near Warren Avenue. It is protesting the hiring of two black firefighters, among the first in the department. One of them, Marcena Taylor, endured years of abuse but persevered to become the first African American battalion chief in department history in 1969.

In 1931, children compete for a piece of fruit at the office of the *Detroit Peoples News*. The *Peoples News* was one of several newspapers serving the African American community, which was then located on the near east side along Hastings Street. The *Peoples News* featured stories on community events plus wedding, birth, and death announcements. Despite its local emphasis, the newspaper's masthead boasted an eagle clutching a globe with the motto World News on the Wings of Power emblazoned across its wings.

Henry Ford's passion for self-sufficiency extended even to his workers. To encourage thrift, he established several company-subsidized stores near his Highland Park plant, offering groceries, clothing, and other necessities to Ford employees only. Even a bakery was included. Shown here are four bakers toiling in the mammoth kitchen.

University of Detroit students participate in an antiwar rally in 1936. Prior to the outbreak of World War II, political attitudes on many U.S. campuses were simultaneously anti-Hitler and isolationist. This sentiment is especially evident in the image below. The placard reads, "True Education Fosters Americanism." Despite this apparent contradiction, college students of the era were keenly interested in the developing situation in Europe. Interestingly, this speech is being given at the base of the university's clock tower, dedicated to students and alumni who served in World War I.

Similar attitudes were represented on the campus of Wayne University. In this image, a group of students listens with great intensity as the speaker enumerates her points. The placard reads, "Students Protest War and Fascism."

A flyer announces an organizational meeting for the Ford Hunger March scheduled for March 6, 1932. The next day, laid-off Ford workers marched down Fort Street toward the Rouge plant to protest the lack of work and what they perceived as Henry Ford's insensitivity. Confronted with water cannons and gunfire from police and Ford security, five protesters were killed and many more injured.

As the 1930s progressed, the oppressive Nazi regime gradually gained power and struck fear in the hearts of millions of Americans. This 1938 image shows an unequivocally anti-Nazi protest in front of the German consulate on Woodward Avenue. By this time, many Detroiters could see the inevitability of war.

As Detroit and the nation were just emerging from the depths of the Depression, entrepreneurs aggressively marketed their products. In what appears to be an outdoor trade show, model houses promoting home improvements line the median of Washington Boulevard in this 1935 image.

The Pewabic Pottery factory on East Jefferson Avenue is the home of an artistic legacy that continues to thrive today. In 1903, Mary Chase Perry and Horace Caulkins established their business on Alfred Street, moving to this Tudor Revival structure designed by William Stratton in 1907. Together they pioneered a new method of forming ceramic tiles and vessels. The items featured an unusual glaze and a beauty revealed in their simplicity. The tiles became exceptionally popular in upscale homes and buildings throughout both Michigan and the United States. Enduring the test of time, the factory continues to produce products as a nonprofit entity. Today Pewabic Pottery is recognized as Detroit's unique contribution to the arts and crafts movement. (Author's collection.)

Vases of various shapes on display at the Pewabic Pottery factory show the versatility of the medium. Perry chose the Native American word *Pewabic*, the name of a mine located near her childhood home, to identify her creation.

Surrounded by dozens of imaginative pieces, Mary Chase Perry mixes glaze to be applied to new creations about to be fired. The image below shows Perry preparing to insert a new item in the kiln.

50

The association between Perry and William Stratton was more than just professional. After their marriage, each pursued their related professions for several decades, often collaborating. This is clearly evidenced in the Women's City Club. Established in 1919, the club was formed to "promote a broad acquaintance among women." The structure was designed by Stratton in the arts and crafts style and features, quite fittingly, numerous displays of Pewabic tile.

This tranquil image of the grotto behind the building shows the warmth and the simplicity of Pewabic tiles. Locally they can be also seen in places as varied as Sacred Heart Seminary, Chadsey High School, and the McNamara Terminal at Detroit Metropolitan Airport. Such variety is a testimony to the medium's versatility.

In what may be one of the most painstaking public works projects in Detroit, if not U.S. history, crews in these 1936 images are seen shortening two landmark churches along Woodward Avenue to make room for the widening of the street. Scores of structures along the east side of the avenue from Adams Street downtown to Garfield Street in midtown were so altered. North of Garfield Street, the project shifted to Woodward's west side.

Many religious and ethnic groups are represented in Detroit. Despite demographic shifts, a number of their legendary places of worship remain. SS. Peter and Paul Orthodox Cathedral is an example. The west side neighborhood of Michigan Avenue and Livernois was once home to a large Russian community. Located on Gilbert Street, the congregation now serves members throughout the metropolitan Detroit area. This image is of the original church, built in 1908. It was demolished in 1947 to make way for the current structure.

This 1934 image shows services at Congregation B'nai David, then located at Fourteenth Street and Elmhurst Avenue on the city's west side. Prior to moving to this building, the congregation, then known as Beth David, worshipped on the lower east side at 545 Winder Street, its first permanent home. In 1958, the congregation moved to a beautiful new facility in Southfield.

53

The opulent McGregor Library in Highland Park harkens back to an era when the community was blessed with automotive-infused affluence. During the 1920s, city officials toured libraries throughout several states before deciding on a design. The building is a combination of the Federal and Italian Renaissance styles. After serving the city for decades, the library closed in 2001 due to budget concerns. Community leaders are currently working to raise funds for an endowment, the proceeds from which will allow for the reopening and continued operation of the library.

In addition to the mammoth Michigan Central Railroad Station and the Detroit Union Station, the city also boasted a third. This image shows the Grand Trunk Railway Brush Street station, located off Brush Street between Jefferson Avenue and the Detroit River. Smaller than its west side counterparts, it primarily served commuters traveling downtown from Pontiac and points north.

Today the beauty of the downtown riverfront bears little resemblance to the once-dominant industrial landscape, which featured large silos and warehouses. This image is of the Henkel Flour Mill in 1928. Later known as Robin Hood Flour, it was demolished in 1972 to make way for the Renaissance Center.

Of the many talented artists who have produced public sculptures for Detroit, Marshall Fredricks is surely the most prolific. His very first, and perhaps least-known, work is the Levi Barbour memorial on Belle Isle. Simple in form, the monument consists of a gazelle cast in bronze in a forward leap. At the base flanking a pool are smaller figures of different animals carved in granite: a rabbit, hawk, grouse, and otter. Levi Barbour was a prominent attorney during the 19th century who advocated to the city the purchase of the island for an urban park.

Belle Isle's beauty is enhanced by its numerous monuments. This particularly touching one by Samuel Cashwan memorializes James J. Brady, founder of the Old Newsboys Goodfellows Fund. Brady, a federal tax collector, saw firsthand the extreme poverty experienced by many Detroit families, which was especially acute during the holiday season. His response was to enlist a corps of former newspaper vendors to sell special commemorative editions. Funds raised were used to purchase holiday gifts for Detroit's needy children—a tradition that continues today.

During the early 20th century, African Americans could only be admitted to a major hospital by a white doctor. Black physicians sought to correct this injustice. In 1918, they formed the Allied Medical Society and in 1919 opened a hospital for blacks in this house on East Frederick Avenue. Named after poet Paul Laurence Dunbar, the facility served the community until 1928, when the society moved to a larger building. Today the house has been restored and serves as the offices of the Detroit Medical Society, the successor to the Allied Medical Society.

This 1930 aerial view shows a sprawling industrial complex on Detroit's east riverfront—probably the city's largest nonautomotive concern. In 1886, Hervery Parke and George Davis established Parke Davis and Company, manufacturing pharmaceuticals. The company became a leader in research, establishing the industry's first modern laboratory. It was also first to conduct comprehensive clinical trials of new drugs. After a succession of corporate mergers, the property was sold in 1982 and redeveloped as upscale office, hotel, and residential properties.

In July 1938, Henry Ford marked his 75th birthday. Seldom has the Detroit area staged any type of celebration in a more elaborate manner. Shown in this image are Ford and his wife Clara making their entrance to a formal dinner for several hundred held at the Masonic temple in Detroit. The night before, Ford's hometown of Dearborn honored its native son with a lavish historical pageant, tracing the history of Dearborn from the pre-Colonial era to the 20th century in 10 episodes.

Yet another commemoration of Ford's milestone birthday was held at the Michigan State Fairgrounds Coliseum. This event, geared toward children, featured dancers, floats, bands, and even acrobats. The image below shows the audience leaving after the celebration. Note both the tremendous size and the diversity of the crowd.

Henry and Edsel Ford pose with actor Charlie Chaplin (center) in this 1923 image, taken while Chaplin toured the automakers' Highland Park plant. Thirteen years later Chaplin would spoof mass production (then colloquially known as Fordism) with his making of the classic silent film *Modern Times*. In the film, Chaplin's character is repeatedly fired from a series of jobs, usually for his inability to perform efficiently. After each termination, he is arrested and jailed (sometimes intentionally) for absurd reasons. The movie ends on an optimistic note, showing Chaplin and his girlfriend dancing into the distance toward what they hope is a better future. In 1989, the Library of Congress deemed the film "culturally significant" and included it on the National Film Registry.

Dr. William Valentiner, pictured here, was a native of Germany who served as director of the Detroit Institute of Arts from 1924 to 1944. During his tenure, the museum's current building on Woodward Avenue was opened. In 1931, working with Edsel Ford, Valentiner commissioned Diego Rivera to paint the famous *Detroit Industry* frescos. Architect Paul Cret, who had designed the building less than a decade earlier, was outraged at the plan, claiming his building was being desecrated. Despite appeals to city leaders and to his friend Albert Kahn, Valentiner's plan became a reality.

The exquisite Italian Renaissance home of Russell Alger Jr. on Lakeshore Drive in Grosse Pointe Farms was originally called the Moorings. Following Alger's death in 1930, the home was used as a branch of the Detroit Institute of Arts. In 1949, the structure took on the duel role of community center and war memorial. Today it enjoys status as both a state and national historic site.

John Christian Lodge's name is truly iconic in Detroit political history. Lodge, for whom the expressway is named, began his career as the city editor for the *Detroit Free Press* during the 1890s. Lodge later ventured into politics as a member of common council. During the 1920s, he served three separate stints as mayor. Lodge was also the great-uncle of aviation pioneer Charles Lindbergh.

The venerable Connie Mack, manager of the Philadelphia Athletics, studies the field during a 1929 matchup with the Tigers at Navin Field. Mack, who at this time was also part owner of the Athletics, refused to wear a uniform while managing, opting for a business suit instead.

Three members of the Detroit Cougars hockey team practice during the 1929 season. Originally located in Victoria, British Columbia, the team was acquired by a group of Detroit investors in 1926. Later the team changed its name to the Detroit Falcons before settling on the Red Wings as its moniker in 1932. The Depression hit the young team extremely hard, at one point forcing coach Jack Adams to use his own money to meet the payroll.

This image of a somber Lou Gehrig was taken at Navin Field on May 5, 1939, the final day of his storied baseball career. During the previous two seasons Gehrig's trademark strength and endurance had faltered. Seeing this unfortunate progression, Gehrig, as Yankees team captain, elected to end his amazing streak of 2,130 consecutive games. Eventually he was diagnosed with amyotrophic lateral sclerosis, the disease now identified with his name.

The attack on Pearl Harbor in 1941 galvanized the American people toward a common purpose: defeat of the Axis powers at any cost. Government-issued bonds were one tool used to finance the war effort. The appeal emblazoned on the side of this streetcar illustrates their importance.

Four

TOIL AND GRIT
1940–1959

Following the brutal experience of the Depression, Detroit's economic fortunes improved somewhat as 1940 approached. This was due to the combined effects of the New Deal and the gradual ramp-up in military production.

Following the attack on Pearl Harbor, the United States and Detroit were thrust into World War II with an enormous challenge: to transform its industrial might to produce much of the military hardware needed for victory. The city met this challenge but not without difficulty. A principal obstacle was Detroit's poor race relations. Numerous "hate strikes" initiated by angry white workers being forced to work alongside blacks caused disruptions in war production. These frustrations culminated in the 1943 insurrection, resulting in the deaths of 34 Detroiters.

After the war, related challenges would continue to confront the Motor City: ongoing issues of race relations and the beginning of the population shift to the suburbs. How Detroit would deal with these issues would define its character in subsequent decades.

As Detroiters returned from the war, a new social equality was the aim of the GI Bill. Low-interest government-backed mortgages plus taxpayer-funded college tuition sought to lift the fortunes of war veterans as gratitude for their service. These newly educated citizens soon achieved a level of affluence and saw the attractiveness of new homes on virgin land. Newly constructed expressways and extended Detroit water lines added to the appeal.

At the same time, persistent forms of racial discrimination by local government and businesses in the areas of housing and employment set the stage for the suburbs being largely for whites while blacks were confined to the city proper. But for many, the irresistible tug of the suburbs had begun. There would be no looking back.

Striking Ford workers huddle in this April 1941 image. This strike at the Rouge plant in Dearborn represented the culmination of a decade-long struggle to unionize Ford Motor Company. Like many other strikes, the 1941 incident was marked by violence, as shown in the image at left. On April 14, the strike ended when Ford formally recognized the United Auto Workers, becoming the last of the Detroit automakers to do so. For all parties, the timing was fortuitous. After the United States' entry into World War II, the United Auto Workers proclaimed a no-strike pledge to the automotive companies and the government for the duration of the war.

During World War II, public green spaces were often devoted to temporary military facilities. This Marine Corps recruiting station was constructed in June 1942 on the grassy island of Washington Boulevard. Amazingly, it took only one day to build.

In anticipation of the United States' entry into the war, the Packard plant on East Grand Boulevard undergoes an expansion in early 1941. During the war, Packard built the V165 engine (under permission from Rolls-Royce) to be installed in the P-51 Mustang fighter for use in the European theater. The company also produced various V12 marine engines to be used in Pacific-bound PT boats.

A long line of prospective soldiers await induction into the army at the Fort Street recruiting station. Over 200,000 Detroiters served in various branches of the armed services during the war. Combined with the city's massive contribution of military hardware, Detroit's total participation in the war effort rivaled that of few other cities.

War preparations extended even into Detroit's schools. Here students at Cass Technical High School practice physical training. In Detroit and throughout the nation, many schools realigned their gym classes for males to prepare them for boot camp.

Students at the University of Detroit study the engine of a military vehicle, most likely an ambulance. During the war, thousands of college students enrolled in courses related to the military—engineering, radio electronics, emergency medical procedures, and the like—to prepare for either eventual induction into the armed forces or civilian defense plant employment.

The Detroit Public Library's bookmobile stops at Campus Martius in 1940, its first year of operation. Detroit officials recognized early on the need to provide services to customers for whom getting to the library was difficult or impossible: the elderly, infirm, and incarcerated. Reorganized as the extension department in 1947, bookmobiles and other outreach programs were employed with energy and dedication in successfully reaching those citizens. These included book loan programs to nursing homes and the establishment of a collection of books for the blind. Many of these programs continue today and operate from the Frederick Douglass Branch on Detroit's west side.

Actor Mickey Rooney (center) jokes with Edsel and Henry Ford in 1940. The occasion was the premiere of his new movie *Young Thomas Edison*, which debuted in Edison's boyhood home of Port Huron on February 10. In the movie, Rooney presents Edison's serious nature as a youth, his intellectual talents, plus his overcoming the difficulties caused by his loss of hearing.

In the years immediately prior to the Pearl Harbor attack, the issue of military conscription ignited intense debate. While a solid majority favored the draft, a vocal minority missed few opportunities to promote its dissenting views. This group included labor leaders, the American Youth Congress, and, for a time, First Lady Eleanor Roosevelt. A particularly colorful opponent was Elane Summers, a college student from Rockford, Illinois, who went by the alias Pauline Revere. Dressed in Revolutionary War garb, she rode a horse while carrying a placard reading, "Mobilize for Peace, Defeat Conscription."

73

The ever-increasing stress of wartime production, an acute housing shortage, and a massive influx of newcomers from divergent backgrounds combined to touch off an insurrection during the summer of 1943. On Sunday, July 20, exaggerated rumors circulated of conflicts between blacks and whites on Belle Isle, prompting widespread panic. Violence then erupted along the Woodward Avenue corridor. In the image below, a white mob overturns the car of a black motorist, apparently oblivious to the consequence.

In this image, spectators watch a car smolder. The extent of the mayhem forced Gov. Harry Kelly to request federal troops to restore order. After their arrival on Monday evening, July 21, calm was restored. Despite concern over property damage and the loss of life, the loss of armament production time was recognized as the costliest causality.

Henry Ford II is pictured in his naval uniform with his first wife, Anne, in this 1941 image. Following his father Edsel's untimely death in 1943, the navy took the unusual step of discharging Henry from the service to run Ford Motor Company, a major defense supplier. Military leaders feared the eccentric and often bizarre behavior of Ford's grandfather Henry Ford I would hamper the company's production capabilities.

World War II brought rationing of a myriad of consumer goods. Soon after the Japanese attack on Pearl Harbor, an elaborate system of tokens, coupons, and other methods controlled the distribution of food items, clothing, gasoline, tires, and so on. These policies were administered by local rationing boards. Most documents had to be picked up in person as this 1942 image shows. Note the racially integrated clientele, as the system treated all citizens equally.

Grosse Isle in the Detroit River was the home to one of the U.S. Navy's air stations, which included a naval training school for Allied pilots. In August 1941, these British cadets arrived to begin their training under U.S. command. Those who successfully finished the program would be transferred to Pensacola, Florida, to complete their training.

During the war, Fort Wayne at Jefferson Avenue and Livernois Avenue served as a POW camp for captured Italian soldiers. This image shows inmates participating in military inspection before American commanders. Several other POW facilities were scattered throughout Michigan, including Augusta, Owasso, and Romulus.

Two Italian inmates tend to their uniforms. Axis soldiers in U.S. custody received excellent treatment, in strict observance of the Geneva Convention.

Max Stephan was a leader in Detroit's German American community during the war. On April 20, 1942, Stephan hosted a German POW, Hans Peter Krug, who had escaped from a Canadian facility near Toronto. Stephan took Krug on a tour of the city's east side, stopping at a series of bars before sending him on to Chicago. After being captured in the Southwest, Krug was brought to Detroit to testify against Stephan, who had been arrested and charged with aiding an enemy of the United States. After being convicted, Stephan's penalty of death was reduced to life imprisonment by Pres. Franklin D. Roosevelt.

The triumphant end of World War II in the Pacific brought thousands of jubilant Detroiters to the streets in numbers not seen since Armistice Day in 1918. Here young people join with enlisted navy personnel during the celebration.

Detroit's small Chinatown celebrates V-J Day with the traditional procession of the dragon. Detroit's Chinese no doubt felt a special joy in the Allied victory, since their homeland had been a victim of the Japanese.

81

Visitors to the J. L. Hudson Company store gaze intently at captured German war paraphernalia in this February 1945 image. As the war in Europe neared its end, U.S. military leaders sought to educate the American public to the extent of the Nazi horrors by placing the items on public display.

Besides cars, Ford Motor Company was also a pioneer in commercial aviation. In 1925, the Ford Airport in Dearborn opened, visible in this aerial image. The airport served the needs of early air travelers through the Ford Air Transportation service, which provided service to several midwestern cities. The nearby Dearborn Inn on Oakwood Avenue opened in 1931 as the nation's first airport hotel. Beginning in 1926, Ford also built its Tri-Motor aircraft at an adjacent plant. The plane was affectionately dubbed the Tin Goose, a counterpoint to the Model T automobile, known as the Tin Lizzie. This image was taken in 1947 shortly before the airport closed.

In 1948, the City of Detroit adopted as official the flag designed by David Heineman in 1907. In the center is a version of the city's crest. It shows two women, one weeping while the city behind her burns, a reference to the fire of 1805 that destroyed the village of Detroit. The other shows a confident woman in front of the rebuilt city. The Latin motto along the border, *Speramus meliora resurget cineribus*, was written by Gabriel Richard soon after the blaze. It translates, "We hope for better things, it will arise again from the ashes." The city's official motto, it continues to appear on municipal documents today. The four corners of the flag represent the four nations that have controlled the area of Detroit during its history (clockwise from upper right): Spain, Britain, France, and the United States.

The immediate postwar years brought prosperity back to Detroit and the nation. Sacrifices made during the war years ended, replaced by the return of the many pleasantries of American life. In this 1951 image, throngs of shoppers patronize downtown retailers, while the large banners on display commemorate the 250th anniversary of the city's founding.

Henry Ford II meets with Israeli prime minister David Ben Gurion in 1951. Soon after taking over the reigns of his family's company during the war, Ford sought to separate the Ford legacy from the anti-Semitism for which his grandfather was known. According to historian Alan Kandel, in 1948 Ford sent to Israeli president Chaim Weizmann a gift of one of only two Lincoln automobiles then available. The other was given to Pres. Harry Truman.

Mariner's Church makes its slow, labor-intensive move 880 feet eastward in this 1955 image. Made necessary to make room for the long-awaited civic center, the move forced the closure of Woodward Avenue for 21 days. At its current location, the church's graceful architecture greets visitors arriving to the United States from Canada via the Detroit–Windsor Tunnel.

Part billboard, part historical testimonial, the famous Detroit stove dwarfs the gentleman peering up at it in this 1957 image, taken at the stove's original Detroit location on East Jefferson Avenue near Belle Isle. Stove making was one of the preeminent Detroit industries during the late 19th century, just prior to the automotive age. Originally constructed for an exhibition in Chicago, the stove was moved to Detroit to serve as an advertisement for the Detroit Stove Works. In 1965, it was moved to the state fairgrounds. The stove was dismantled in 1974 due to age and decay, but after being restored and reassembled in 1998, it was returned to the state fairgrounds.

Legitimate, or live, theater in Detroit thrived on a small scale during the latter half of the 19th century. Early venues such as the Metropolitan, the Varieties, and the Courique operated on Jefferson Avenue downtown. The Schubert Theater, located at Lafayette Boulevard and Shelby Street, opened as the Orpheum in 1914. Managed by D. T. Nederlander, the theater's productions showcased the stars including Jack Benny, Gloria Swanson, Rex Harrison, and Bette Davis. Following the Schubert's razing in 1964, the Fisher Theatre became the major focal point of onstage entertainment.

Architect Frank Lloyd Wright supervises final details on the Turkel House, located on West Seven Mile Road. The house is the only Wright structure in Detroit. Constructed predominantly of concrete Usonia blocks, the house represents the final evolution of Wright's style: practical yet fashioned in a clean, contemporary manner. After several years of abandonment, the house is currently undergoing a thoughtful restoration by its new owner.

Without question, the most cryptic private club in Detroit is the Yondatega Club. The club's title derives from the Algonquin word for "beautiful view," the name the tribe used to describe the area of present-day Detroit. Pictured here is the original clubhouse located at 518 East Jefferson Avenue. After moving in 1959 to make way for the Chrysler Freeway, the club lost none of its mystery as an exclusive dining club limited to 150 men where visitors are rarely allowed. Guests throughout the club's history have included Adm. Richard Byrd and Theodore Roosevelt, who proclaimed it "the finest club in America."

Detroiters will recognize this 1955 image as highly unusual—it shows the soon-to-be-completed city-county building before the famous *Spirit of Detroit* statue was installed. The exposed wall allows the observer to see the entire biblical inscription: "Now the Lord is that Spirit and the Spirit of the Lord is Liberty" (2 Cor. 3:17). The quote was chosen by Mayor Eugene Van Antwerp in concert with his son George, a Catholic divinity student. Together they sought to select a passage emphasizing the primacy of freedom.

Just as their predecessors had in 1871, on July 22, 1955, city officials processed from the old city hall to its successor. This image shows the dignitaries proceeding down Woodward Avenue toward the city-county building, led by a police honor guard.

Mayor Jerome Cavanagh speaks to well-wishers at the 1966 dedication of Plum Street. Located just northwest of downtown and conceived by Robert Cobb and Sherman Shapiro, Plum Street was envisioned as a planned community for artists, musicians, and other creative types. Unfortunately a combination of negative forces prevented its success: drugs, motorcycle gangs, and eventually the 1967 insurrection. During its brief lifetime, however, Plum Street provided an outlet for a new generation of artists and benevolent hippies, much like Haight-Ashbury in San Francisco.

Five

HOPE AND TRAGEDY
1960–1980

Many of the social and economic trends that faced Detroit during the immediate postwar years reached a high water point during the 1960s. Despite gains won by new civil rights legislation, the pace of urban abandonment accelerated, culminating in the 1967 rebellion.

Despite the gravity of these serious developments, however, Detroit, like much of the nation, found itself in the midst of a cultural revolution, the trademark characteristic of the decade. While this often conjures memories of protests and love-ins, the era also sported a lighter side: the introduction of a teen advisory board at the J. L. Hudson Company, allowing the retailer to listen more closely to its younger customers, and the opening of Plum Street, Detroit's unsuccessful yet well-intentioned nod to the artistic community.

Despite persistent racial and economic polarization, Detroiters continued to unite to celebrate special events, most notably the 1968 World Series victory. This spirit continues today, evidenced in the diversity seen in the annual Focus: HOPE walk for justice and in the crowds lining Woodward Avenue each year for America's Thanksgiving Parade.

The shops along Plum Street, while all related to the artistic side of life, varied from the serious to the whimsical. Shown above on the left is the Book House flanking its neighbor Of Cabbages and Kings, an antique store and interior design studio. The Sugar Shack, an out-of-the-way coffee outlet, is set back from the street. Shown below are several businesses sharing a building: the Studio Music Shop, the Emporium, and Pic-A-Pearl, where customers could choose a pearl from a live oyster to be set in a personally selected piece of jewelry. Note the bathtubs reused as planters on the sidewalks.

The 19th-century building now known as Trappers Alley was originally the home of Traugatt Schmidt and Sons Furrier and Tannery. Most Detroiters will remember the 1980s development of the Trappers Alley in Greektown as a shopping venue. Prior to the area's reconfiguration, however, a few pioneering stores took up residence. Pictured in the 1973 image above is proprietor John Piaszak in his unique store the Plum Pit. Below is owner Patricia Brown (right) in her boutique, Little Things.

Of the many grand homes in Detroit, the Manoogian Mansion on Dwight Street boasts a special distinction: since 1965 it has been the official home of the mayor. Built in 1928 in the Spanish Colonial Revival style, the home was purchased at a foreclosure auction in 1938 by entrepreneur Alex Manoogian. After raising his family in the home, Manoogian donated it to the city. Today Detroit and New York are the only two major U.S. cities with official mayoral residences.

This home at 1220 West Forest Avenue serves as a Wayne State University fraternity house in this 1962 image. No longer standing, it was the birthplace of famous pilot Charles Lindbergh. Lindbergh led an accomplished yet controversial life. After his famous transatlantic flight, he emerged as a powerful voice in the American isolationist movement and was believed to have fascist sympathies. After marrying in 1929, personal tragedy struck two years later when the Lindberghs' infant son Charles was kidnapped from their New Jersey home. The detective who conducted the criminal investigation was Col. Norman Schwarzkopf of the New Jersey State Police, father of the Desert Storm commander.

During the 1960s, an interest in the preservation of historic structures became a greater social priority. This 1967 image is of the Moross House at 1460 East Jefferson Avenue, taken shortly before its restoration. The image below shows the house after the project's completion. The Moross House, the oldest-known masonry structure in the city, was built by brick maker Christopher Moross between 1842 and 1848. Designed predominantly in the Federal style, the house does possess some Greek Revival features, most notably the lintels over the windows and doorway. Today the house enjoys a new life as the home of the Detroit Garden Center.

The Alexander Chene House on East Jefferson Avenue was an outstanding example of the Federal style. Built in 1855, the building served as a private residence and a University of Detroit fraternity house before becoming the Little Harry's restaurant, which it remained until the early 1990s. In the early 1970s, a scene from the movie *The Betsy* was filmed in the dining room.

Without question, the premier Detroit dining spot for most of the 20th century was the London Chop House on West Congress Street. From 1926 to 1991, the venerable restaurant, which specialized in generously sized steaks and chops, served Detroit's elite plus noted celebrities including Frank Sinatra, Gary Cooper, and Errol Flynn. The walls featured caricature drawings of many of these luminaries. Since its 1991 closing, several attempts have been made to reopen the venue. None, however, have so far succeeded.

Topinkas's Restaurant on West Grand Boulevard enjoyed many years as a Detroit institution, augmented by its proximity to the Fisher Theatre. Seeing a celebrity cast member dining after a performance was not an unusual sight.

In 1961, the Fisher Theatre, which had been a movie and vaudeville house, reopened as a venue for live productions after extensive renovations. This image is from the inaugural performance, *The Gay Life*, starring Barbara Cook and Walter Chiari, on September 30, 1961. Over the years, the Fisher has hosted the pre-Broadway premieres of *Hello, Dolly!*, *Fiddler on the Roof*, and *Sweet Charity*.

In the early 1960s, civic leaders in Detroit made a proposal to the International Olympic Committee (IOC) to host the summer games scheduled for 1968. Elaborate presentations were given to Olympic officials featuring colorful renderings of planned facilities, including an enormous stadium at the state fairgrounds to accommodate the track and field events. This image shows Detroit mayor Jerome Cavanagh and Michigan governor George Romney explaining plans to IOC chairman Avery Brundage. Unfortunately Detroit's bid was unsuccessful as the games were ultimately awarded to Mexico City.

The Charles Lang Freer House on East Ferry Street was the late-19th-century home of a wealthy railroad icon. The home was constructed in the unusual shingle style with Pewabic tile throughout. An avid art collector, Freer amassed a priceless collection, so large he twice needed to expand the home to accommodate it. After Freer's death, the collection was donated to the Smithsonian Institution and is today known as the Freer Gallery of Art in Washington, D.C. Since the 1960s, the house has been creatively reused as home of the Merrill Palmer Skillman Institute, a highly respected center for child advocacy research.

As the century progressed a new generation of local architects emerged. Many buildings by Minoru Yamasaki, a gifted member of this group, can best be called masterpieces. Although not a Detroit native, Yamasaki lived in the area during most of his career, contributing the McGregor Center at Wayne State University and the American Natural Resources building on Woodward Avenue to his adopted hometown. He also designed a new airport in the Saudi Arabian capital of Riyadh. The Saudi regime admired the design so much it placed an image of it on its currency.

Architecture and public art interact gracefully in this image. In a view looking north from Hart Plaza, Isamu Noguchi's *Pylon* marks the end point of Woodward Avenue as well as the nearby international frontier. Flanking the sculpture on the left is the American Natural Resources tower designed by Yamasaki and constructed in the early 1960s. The architect later designed the World Trade Center in New York, which bore some resemblance to the Detroit structure. On the right is a partial view of the city-county building, which, as the seat of city and county government, is a major component of Detroit's civic center.

Bob McNea portrayed Bozo the Clown on WWJ-TV in Detroit from 1959 to 1967. Most major U.S. cities had a locally produced Bozo show on regional television, since the Bozo character was franchised by its creator as opposed to being syndicated nationally. This image offers a rare look of McNea without makeup. McNea was succeeded by Art Cervi, who played Bozo until 1980 from CKLW-TV Windsor and later from WJBK-TV in Detroit.

Clare Cummings played the character of Milky the Clown on Detroit television during the 1950s and 1960s. Unlike Bozo, Milky was exclusively a local figure, dressed in a white costume designed by his wife (styled after the clown in the Italian opera *I Pagliacci*). *Milky's Movie Party* and later *Milky's Party Time* entertained children in the studio and at home with games, cartoons, and magic tricks. The show, sponsored by the Twin Pines Dairy, also had the commercial purpose of promoting the company's worry-free home delivery.

Detroit seldom fails to celebrate anniversaries of momentous events. In this 1961 ceremony, a historical marker is dedicated recalling the mobilization of the 1st Michigan Infantry Regiment in April 1861. Michigan was the first to answer Pres. Abraham Lincoln's call for volunteers following the Confederate attack on Fort Sumter, South Carolina, on April 12.

Shown shortly before its recent restoration, the Russell A. Alger memorial is a noteworthy landmark on the east side of Grand Circus Park. Designed by Henry Bacon and David Chester French, the monument honors Russell A. Alger, a wealthy industrialist who served as governor of Michigan from 1885 to 1887. He was appointed a U.S. senator from Michigan in 1902 and served until his death in 1907. This sculpture shows a mythical female figure representing the state of Michigan. Her right hand is raised as a greeting of peace. Her left hand holds a shield emblazoned with the great seal of Michigan, a symbol of defense.

The nation's enduring gratitude to the GAR continued long after its generation had passed. Sculpted by Angelo Zirolo of Wyandotte and sponsored by the Women's Relief Corps (an affiliate of the GAR), this simple memorial of a Union soldier was dedicated on Belle Isle in 1948. The inscription reads, "There are now forty eight reasons why we will always remember the Grand Army of the Republic."

A taste of Rome in Detroit, this elegant, proportional bust of Italian poet Dante Alighieri shares quarters on Belle Isle with a nearby picnic pavilion. His seminal work, *The Divine Comedy*, remains a literary classic today. The sculpture, executed by Raffello Romanelli, exhibits classic Roman features: a symmetrical massing, a stern facial expression, and a laurel wreath.

When one normally thinks of the Duesenberg, a picture of a luxury automobile from the 1920s emerges. Little known, however, are the several post–World War II attempts to revive the brand. In the mid-1960s, Fritz Duesenberg, son of founder August Duesenberg, styled a modern version of the storied automobile using a 1966 Chrysler Imperial chassis and engine. In this image, the car is shown on display at the Statler Hotel.

June 23, 1963, was a historic day for not only Detroit but the entire nation. On that date civil rights leader Martin Luther King Jr. led a poor people's march down Woodward Avenue. Detroit was the first major U.S. city to give King this opportunity, due largely to the progressive social policies of Detroit's Mayor Jerome Cavanagh. At the rally that followed at Cobo Arena, King gave an early version of his "I have a dream" speech, made famous later that summer during the march on Washington.

Few images from the 1960s are as somber and chilling as those documenting the assassination of Pres. John F. Kennedy. Anyone old enough to remember that day recalls precisely where they were and what they were doing when learning of the tragic news. In a manner reminiscent of New York's Times Square, these Detroiters read of the events on the WXYZ News sign mounted on the Detroit Bank and Trust building on Griswold Street at Capitol Park. In the image at left, the wreaths at *The Spirit of Detroit* pay silent tribute to the fallen president.

The civil disturbance in July 1967 began in the area of Twelfth Street and Clairmount Avenue on the city's west side. While the violence spread throughout much of the urban core, random pockets extended outward toward the city limits. The Grand River corridor, shown here, was an example. Sporadic disorder occurred along the thoroughfare as far north as McNichols Avenue.

As the horrific week wore on, the gradual buildup of police, National Guardsmen, and federal troops eventually restored order. This poignant image shows a member of the 82nd Airborne Division unwrapping a candy bar.

In the aftermath, a still intact party store near the center of the disturbance prepares to reopen. Many businesses painted the phrase *soul brothers* across their windows in an attempt to thwart looters, with mixed results. In the subsequent months and years, it became sadly apparent that the insurrection was a pivotal turning point for the city, exacerbating trends toward further racial and economic disparity.

Almost immediately after order was restored, politicians, community leaders, and academics attempted to determine the causes of the disturbance and how those trends could be reversed. On July 30, 1967, only days after the violence had subsided, Mayor Jerome Cavanagh was the guest on the NBC Sunday talk show *Meet the Press*, shown here with host Edwin Newman. During the interview, Cavanagh blamed the episode on continuing racial discrimination and ineffective responses from Congress to alleviate poverty.

In an effort to address the issue of urban unemployment, many local companies renewed their commitment to providing jobs to the chronically unemployed. In this image, applicants wait to be interviewed for positions with Ford Motor Company. Note the considerable length of the line.

Never failing to display his trademark charisma, Sen. Robert Kennedy greets African American citizens in the Twelfth Street area while campaigning for the 1968 Democratic presidential nomination. One wonders how history would have unfolded if not for his tragic assassination.

Although the trends contributing to urban abandonment were well entrenched by the late 1960s, significant signs of the city's vitality remained. This image shows the downtown shopping district along Woodward Avenue during the holiday season of 1968. Shoppers and office workers mingle amid the outdoor displays and the bustling stores.

Although the history of Detroit television contains many colorful personalities, the late Lou Gordon occupies a special place. From 1965 until his sudden death in 1977, Gordon hosted a weekly interview show on WKBD-TV featuring a wide variety of guests but with a special emphasis on Michigan politicians. Guests often grew uncomfortable and angry when confronted with Gordon's intense questioning, occasionally walking off the set. In a 1967 appearance, Gov. George W. Romney remarked he had been "brainwashed" by U.S. military leaders during a recent fact-finding trip to Vietnam. His inadvertent use of this inflammatory word effectively ended his quest for the 1968 Republican presidential nomination.

Protests against American involvement in Vietnam were common on many college campuses and in several U.S. cities. Detroit was no exception. In this 1969 image, Wayne County sheriff's deputies on horseback attempt to disperse a downtown antiwar demonstration.

Racial and political transition in Detroit was illustrated most dramatically by the controversy over the STRESS police unit. Formed in 1971, STRESS (an acronym standing for Stop the Robberies, Enjoy Safe Streets) was an undercover decoy unit known for using very rough, even brutal tactics in its attempt to thwart drug dealers. As its abuses became more apparent, public support waned while the police commitment to maintaining the unit remained steadfast. Eventually police commissioner John Nichols ran for mayor in 1973 on a pro-STRESS platform. His opponent, Coleman Young, pledged to abolish STRESS, ultimately propelling him to victory as the city's first black mayor.

A demonstration of a different but no less significant kind occurred at the Detroit Athletic Club in October 1975. At the time, women (who were still barred from membership) who entered the building were required to use a side entrance. Archaic by today's standards, this rule allowed for no exceptions. When city councilwoman Maryann Mahaffey arrived to attend a scheduled meeting, she became incensed at being turned away at the main entrance. The next day protesters from the National Organization for Women occupied the club, as shown here. To its credit, the Detroit Athletic Club today boasts a diverse membership and a welcoming facility.

Within the American tradition of church and state separation, ceremonial interactions of religious and secular officials are rare. A noteworthy exception is the annual Red Mass held at the University of Detroit Mercy Law School. At this annual event, members of the legal community pray for divine guidance and renew their commitment to upholding the United States Constitution. An English tradition dating from around 1310, the liturgy is so named for the color of the vestments worn by the celebrant.

Due to rules forbidding television cameras, seldom do members of the public not party to a lawsuit get to see the inside of a federal courtroom In this 1978 image, however, federal judge Damon Keith is holding a press conference for a group of students. The venue is his ornate seventh-floor courtroom in the federal courthouse on Fort Street. The gentleman taking notes to Keith's right is former *Detroit News* columnist Charlie Manos.

Special individuals known for doing truly heroic work feature prominently in Detroit's history. A recent example is Rev. Clement Kern, pastor of Most Holy Trinity Catholic Church in Corktown. As pastor from 1946 to 1977, Kern expanded the congregation's already strong commitment to the poor, establishing free medical and legal clinics plus the ongoing open-door program. The latter provides a place for the homeless to shower and to receive clean clothing and personal hygiene items. Most Holy Trinity's tradition of service dates to the church's founding in 1834.

St. Matthew's and St. Joseph's Episcopal Church at Woodward Avenue and Holbrook Avenue owes its unusual name to a 1971 merger of two congregations. At that time, St Joseph's (the original occupant of this structure) joined with St. Matthew's, then the city's oldest black Episcopal parish. The result is a wonderful example of integration. (Author's collection.)

Yet another Detroit retail tradition ended when Crowley Milner and Company closed its downtown department store in 1977. Despite the closure, however, Crowley's remained very much a Detroit institution, retaining its Detroit headquarters and two additional stores within the city limits. Crowley's also ran several successful suburban locations until the late 1990s when competition from much larger rivals forced it into bankruptcy.

Following the demolition of the Ernst Kern Company department store in 1966, an urban park was created while the parcel awaited redevelopment. Owing its unusual shape to the geometry of Woodward Avenue's street plan, the addition of the diagonal sidewalks gives the site a resemblance to the Chrysler pentastar, which is purely coincidental. Today this block is home to the new Compuware headquarters.

Prior to the emergence of the current theater district surrounding Grand Circus Park, the blocks immediately east of Campus Martius served as the local center of entertainment. The last survivor of these playhouses is the National Theater on Monroe Street, shown above around 1975. The only theater designed by Albert Kahn, this Beaux-Arts architectural treasure now awaits a much-needed restoration. The surrounding buildings, some of which dated from the Civil War period, were unfortunately demolished in 1991.

Highly ironic is the fact that in a city founded by the French, few French restaurants exist today. Until recently one member of this exclusive group was the Pontchartrain Wine Cellars on West Larnard Street. Until its closing in 1991, diners could enjoy authentic French entrees such as tournedos of beef or veal cordon blue. The establishment's most historic accomplishment, however, came in 1937 when owner Hank Borgman revived a German custom of combining sparkling burgundy with champagne. The result became known as cold duck, a popular spirit today.

Detroiters aged 40 or over nostalgically remember an era when a great number of food items were branded and produced locally. Superior potato chips, Velvet peanut butter, and Stroh's beer all contributed to giving the area a strong local identity. Another Detroit food moniker was the Twin Pines Dairy, pictured here. Twin Pines supplied milk, fruit juices, and other essentials to thousands of local households via its familiar beige delivery trucks.

Originally named Hog Island, Belle Isle was once owned by Gen. Alexander Macomb Jr. Later, the city purchased the island for use as a park. Designed in the 1880s by noted landscape architect Frederick Law Olmsted, at 982 acres Belle Isle is the largest island city park in the nation, exceeding even New York's Central Park in size. The western tip of the island, shown in the foreground, is actually landfill installed to accommodate the construction of the James Scott Fountain (the circular area above the trapezoidal pool).

While most fountains and monuments are built to honor a noteworthy citizen, the James Scott Fountain is named for the gambler and community prankster who bequeathed $500,000 to the city after his death in 1910—to build a fountain featuring a life-size memorial in his honor. The use of the money proved controversial with most members of the clergy objecting. Scott had friends in city government, however, and their influence prevailed.

Perhaps no piece of public art in the city is more recognizable than *The Spirit of Detroit*. Frequently a rallying spot for civic ceremonies and protests, the sculpture also evokes spiritual feelings, expressed through the gilt bronze sphere in its left hand, which represents God.

Six

REVIVAL
1981–2009

"We hope for better things, it will arise again from the ashes." When Gabriel Richard wrote those words, he could have not have foreseen the number of times Detroit would need to reinvent itself. Now, however, is clearly one of those times.

During recent years, the center core of the city has seen considerable reinvestment in loft apartments, new businesses, and so on. This chapter offers inspiring images of a few of these. While impressive, these developments only begin to address the seemingly intractable problems of poverty and joblessness. To truly revive, the city needs to see the birth of the next automotive industry, the next software giant, or a new technological or medical breakthrough—born in one of Detroit's excellent research institutions—that will bring substantial economic benefits and international acclaim. Detroit needs a new generation of innovators with the same imagination and tenacity that put the nation on wheels over a century ago. Unlikely? So was the birth of the automotive industry!

Few downtown restoration projects have the visual impact of the recently opened Westin Book Cadillac Hotel. The newly restored Italian Renaissance building houses 455 guest rooms along with 67 luxury condominiums. Its October 2008 reopening (in the midst of a difficult economic climate) has provided a much-needed stimulus for further downtown development. (Author's collection.)

Figures on the 136-year-old soldiers and sailors memorial stand guard over Campus Martius while the recently built 1 Kennedy Square building provides a stunning contemporary backdrop. The new structure is built on the site of the old Detroit City Hall. (Author's collection.)

The Michigan Soldiers and Sailors Monument, shown here in 1929, has been the focal point of downtown for generations. Designed by sculptor Randolph Rogers of Ann Arbor, the structure honors Michigan servicemen who served in the Civil War. It is crafted in an octagonal pattern with four levels of ascending steps. Four eagles rest on the first platform, followed by four male figures, signifying artillery, cavalry, infantry, and navy. Next are four female figures representing victory, union, history, and emancipation. At the pinnacle is a metaphorical female figure representing Michigan, her hands grasping a shield and sword.

123

As Campus Martius Park was restored from 2003 to 2005, necessity demanded the monument be moved slightly to the south. At that time a new time capsule was installed, to be opened by Detroiters not yet born. (Author's collection.)

New projects bring excitement and promise. The architecturally striking Rosa Parks Transit Center is a noteworthy example. Located downtown on Cass Avenue, the new facility will feature 12 bus bays covered by a unique tensile structure plus an ample waiting area with retail shops and a Detroit police ministation. (Author's collection.)

In a clever allusion to the Prohibition era, the Café D'Mongo "speakeasy" maintains an intentionally low profile on Griswold Street. The little-known bar (which features period photographs and memorabilia) is open only 12 hours a week and does virtually no marketing. It even lacks a telephone. Owner Larry Mongo purposely maintains his watering hole in a way reminiscent of the era of illicit liquor. (Author's collection.)

Efforts at urban rejuvenation are most interesting when they celebrate their own unique past. The developers of the Willys Overland Lofts are creatively adapting an old building into a community of luxury apartments. From 1917 until the 1940s, the structure housed sales and service facilities for Willys-Overland Motor Company, a fact proudly announced to Willis Avenue pedestrians. (Author's collection.)

George W. Romney, chairman of American Motors Corporation, leaves his company's Plymouth Road headquarters around 1961. Soon after he embarked on a political career, chairing the convention that revised the Michigan Constitution in 1962 and being elected governor the same year. A true conciliator, Romney refused to put his party affiliation on his campaign signs, claiming to be a citizen first. He also provided steady leadership during and after Detroit's 1967 insurrection. Kelvin's prophetic quote above the portal could hardly be more appropriate.

BIBLIOGRAPHY

Babson, Steve, Ron Alpern, Dave Elsila, and John Revitte. *Working Detroit*. Detroit: Wayne State University Press, 1986.

Ferry, W. Hawkins. *The Buildings of Detroit: A History*. Detroit: Wayne State University Press, 1980.

Gallagher, John, and Eric J. Hill. *AIA Guide: The American Institute of Architects Guide to Detroit Architecture*. Detroit: Wayne State University Press, 2003.

Gavrilovich, Peter, and Bill McGraw, eds. *The Detroit Almanac: 300 Years of Life in the Motor City*. Detroit: Detroit Free Press, 2000.

Georgakas, Dan. *Detroit, I Do Mind Dying: A Study in Urban Revolution*. Detroit: South End Press, 1998.

Hume, Edward. *Over Here: How the G.I. Bill Transformed the American Dream*. New York: Harcourt, 2006.

Kandel, Allen. "Ford and Israel." *Michigan Jewish History* 39 (fall 1999), pages 13–17.

Luedtke. Eleanor. *Promises Kept: The Story of Comerica 1849–1999*. Detroit: Comerica Bank, 1999.

Lutz, William. *The News of Detroit*. Boston: Little, Brown and Company, 1973.

Nawrocki, Dennis, and David Clements. *Art in Detroit Public Places*. Detroit: Wayne State University Press, 2008.

Reilly, Rev. Leo, C.S.B. *Ste. Anne de Detroit*. Ann Arbor, MI: University Lithoprinters, 2001.

Sharoff, Robert, and William Zbaren. *American City: Detroit Architecture 1845–2005*. Detroit: Painted Turtle Books, 2005.

Sugrue, Thomas J. *The Origins of the Urban Crisis: Race and Inequality in Postwar Detroit*. Princeton, NJ: Princeton University Press, 2005.

Wallace, Mary. *Historic Photos of Detroit*. Nashville: Turner Publishing Company, 2007.

www.arcadiapublishing.com

Discover books about the town where you grew up, the cities where your friends and families live, the town where your parents met, or even that retirement spot you've been dreaming about. Our Web site provides history lovers with exclusive deals, advanced notification about new titles, e-mail alerts of author events, and much more.

MADE IN THE USA

Arcadia Publishing, the leading local history publisher in the United States, is committed to making history accessible and meaningful through publishing books that celebrate and preserve the heritage of America's people and places. Consistent with our mission to preserve history on a local level, this book was printed in South Carolina on American-made paper and manufactured entirely in the United States.

This book carries the accredited Forest Stewardship Council (FSC) label and is printed on 100 percent FSC-certified paper. Products carrying the FSC label are independently certified to assure consumers that they come from forests that are managed to meet the social, economic, and ecological needs of present and future generations.

FSC
Mixed Sources
Product group from well-managed forests and other controlled sources
Cert no. SW-COC-001530
www.fsc.org
© 1996 Forest Stewardship Council

Find Your Place in History.